MAGICAL LABYRINTHS

Journeys Through Space and Time

Illustrations by Thomas Thiemeyer
Text by Bertrun Jeitner-Hartmann

Andrews McMeel
Publishing

Kansas City

ISBN: 0-7407-2044-9

— ATTENTION: SCHOOLS AND BUSINESSES —

Andrews McMeel books are available at quantity discounts with bulk purchase for educational, business, or sales promotional use. For information, please write to: Special Sales Department, Andrews McMeel Publishing, 4520 Main Street, Kansas City, Missouri 64111.

Introduction

Discover the secret of the labyrinth and follow its seductive paths! A journey though space and time that brings together dissimilar worlds and offers magical moments awaits you.

You do not need any particular talent to wander through magical labyrinths. Anyone who takes the time can find a way through the entangled and winding paths to the end. Our visual journey goes through the most varied and diverse times and places: from ancient Mayan sites to Celtic stone formations to virtual worlds—from the mythical past into the future.

The History of the Labyrinth

The origin of the labyrinth is yet unexplained. We assume they spread from the Mediterranean region to cultures throughout the world. Their traces are not found only on European soil, in such places as Great Britain, Scandinavia, and Russia, but also in Africa among the Zulu people, in Persia, Rajastan, Tibet, and Afghanistan, and among the Hopi, Pueblo, and Navajo Indians in New Mexico.

Labyrinths were originally places of power and energy. Aligning and placing them correctly required the knowledge of elders and sages. People have tried repeatedly to discover the deeper meanings of such sites with divining rods and measurements of the Earth's energies, and to decipher their riddles by astrological research or cosmic exploration.

Throughout history, the labyrinth has symbolized the entangled path of human existence as a type of "substitute pilgrimage." Labyrinths are compared to the psyche and the inner maturity processes; access to myth and dreams is represented by their multiple paths.

In recent times, labyrinths have experienced a revival. Surely their mysterious vibrations and magnetic attraction represent a counterweight to our empty world void of magic, in which scientists have deciphered the last secrets.

Today, labyrinths come in every shape. They exist before monuments, as places for meditation and communication; in kit form, for games and celebrations; and as meeting places for New Age seekers or for female mystics during full moons.

The Classic One-Way Labyrinth

One-way labyrinths are straightforward guiding labyrinths in which you cannot get lost. Here, the way is the goal. Users follow predetermined paths and have no other choice but to walk all paths until they automatically arrive at the middle—and then out again. The way through these labyrinths is also called the "path to oneself." The powers of the labyrinth are supposed to reveal themselves along the way as a path to self-discovery.

The path through the one-way labyrinth appears to lead almost directly to the center. With the end in sight, the path, however, turns away from the center and wends its way around—frequently almost back to the exit. Then the path turns again toward the center and leads unexpectedly, quickly to the end. The ways in and out count as important experiences; the way in is compared to the passage into the underworld, and the way out represents rebirth.

The layout of one-way labyrinths always follows the same form of circle and cross developed from the three-way labyrinth. Such labyrinths were made of stones or planted as lawns and were later also designed as mosaics—in churches for example.

The Multipath Labyrinth or the Maze

In contrast to the one-way labyrinth, mazes constantly require decisions about which path to take. This emphasizes the self-responsibility of the seeker. Although labyrinths often offer only one solution, they sometimes have several, and those trapped in their tangled paths must demonstrate a sense of orientation and endurance, allow their intuition free play, and leave some dead-ends behind.

Mazes stimulate conversation and make great social games. Popular examples include the garden labyrinths in England, today's hedge labyrinths, the famous "hand" of Uri Geller, the ubiquitous corn field labyrinths, and labyrinths in garden shows.

We find play labyrinths at fairs and creepy labyrinths in old castle grounds, their twists and turns hidden between walls above which one cannot see. To find the way out of such labyrinths, the famous "red thread," or Ariadne thread, is helpful. This is a ball of wool that Ariadne gave to Theseus in the Minotaur's labyrinth on Crete, so that he could let it out and wind it up again to find his way back to the exit.

To find your way through a maze without an Ariadne thread, you should always keep your right (or left) hand on the wall to ensure your arrival at the end or exit. Obviously, this doesn't apply to labyrinths with trapdoors, passwords, or mental exercises that help seekers gain access to other (mind) spaces.

Labyrinths that lead the observer into the depths of an area are found not only in optical illusions or in the fantastic levels of the mind, but also in our daily lives, where one can get lost in corridors on different levels: in drain and subway tunnels under the city, in the catacombs of the Romans, or even in nature, where moles or earthworms dig underground passages.

The **labyrinths depicted** in this book do not actually exist; rather, they are artistic interpretations of magical paths. We cannot prove these imaginary portrayals can stimulate ancient forces in us, but one senses some of the captivation and the magical draw they radiate.

When you succeed in finding your way through a labyrinth with your eyes or finger, you activate your imagination and will experience excitement and relaxation in return. In fact, the way through the labyrinth can be used as a meditation. In any event, labyrinth experts are certain you experience the labyrinth process just by tracing the paths with your finger!

In this sense, we wish you an exciting and stress-relieving experience as you embark on the labyrinth adventures in this book.

The Labyrinths in This Book

The labyrinths on pages 12, 16, 18, 23, 25, and 26 are one-way labyrinths; all others are multipath labyrinths or mazes.
• p. 5: The Labyrinth in the Pyramids offers several paths, but only one solution.
• p. 6: The Celtic Cliff Drawings were copied from a piece of jewelry and have several paths to wander.
• p. 7: The Hedgerow Labyrinth is a maze in which one would find the Ariadne thread helpful.
• p. 8: The Dice Labyrinth features an optical illusion that makes passing through on the only possible path difficult.
• p. 9: The Magic Eye has several dead-ends in store for you.
• p. 10: Passing through the Palace of Minos, a thrilling "folding-concept" labyrinth, requires preparation for a journey.
• p. 11: You reach the high path on the Cliff Village

Labyrinth by climbing and descending stairs.
• p. 12: The Trojan Fortress, a path made of stones, is found in Nordic countries.
• p. 13: Traversing crevasses leads to ever higher plateaus on the Cliff Labyrinth.
• p. 14: You must pass through platforms and ascend winding staircases to reach the exit of the Amazing Screw Labyrinth.
• p. 15: You can reach a higher level of consciousness—with the gods close by—on the Labyrinth on the Himalayas.
• p. 16: The Labyrinth in the Corn Field is now experiencing an unbelievable revival.
• p. 17: You must reach the columns in the Foot of the Giant before you go back to the exit.
• p. 18: The Desert Drawing on the high plateau of Nazca is only recognizable from the air.
• p. 19: You arrive at the center of the site up in the northern Rocky Mountains after a wearisome trek through the Labyrinth in the High Mountains.
• p. 20: The Jewel Shield is a very confusing maze that will appeal most likely to fuss-pots.
• p. 21: In the Pueblo Village, you must find your way using ladders on the various levels of the rooftops.
• p. 22: The Sand Picture shimmers like an optical illusion and requires disciplined decision making.
• p. 23: The Archaeological Finding is a very special coin.
• p. 24: In the Honeycomb Labyrinth you can orient yourself in critical situations by shadows that give away door openings.
• p. 25: The Hedgerow Labyrinth is shaped like a butterfly.
• p. 26: Granite is engraved with a figure from ancient times in the Indian Cliffs.
• p. 27: In the Microprocessor you proceed to the exit on various levels, like through a pipe.
• p. 28: Small flags wave at both ends of the Maze Over the Ice Floes.
• p. 29: The Rings of Saturn is a maze with many solutions, both with and without bridge crossings.
• p. 30: One has to reach the tree in the center of the Mysterious Labyrinth with the Four Towers.

Further Reading

The following books are recommended for learning more about labyrinths:

• Candolini, G. *Labyrinths: A Practical Book to Draw, Construct, Dance, Play, Meditate, and Celebrate.* 1999. 144 pages, Pattloch.
• Candolini, G. *The Mysterious Labyrinth: Myths and History of One of Mankind's Symbols.* 1999. 240 pages, color illustrations, Pattloch.
• Kern, H. *Labyrinths, Shapes and Meanings: 5000-Year Presence of an Archimage.* 1982. 492 pages, 666 illustrations, Prestel (Anniversary Edition 1999).
• Lonegren, S. *Labyrinths: Ancient Myths and Modern Application Possibilities.* 1993. 152 pages, Black-and-white illustrations, 2001.

The journal *Caerdroia*, published by Jeff Saward, appears once annually and deals exclusively with labyrinths. For subscription information, contact: The Caerdroia Project, 53 Thundersley Grove, Thundersley, Benfleet, Essex, SS7 3EB, England. E-mail: caerdroia@dial.pipex.com.

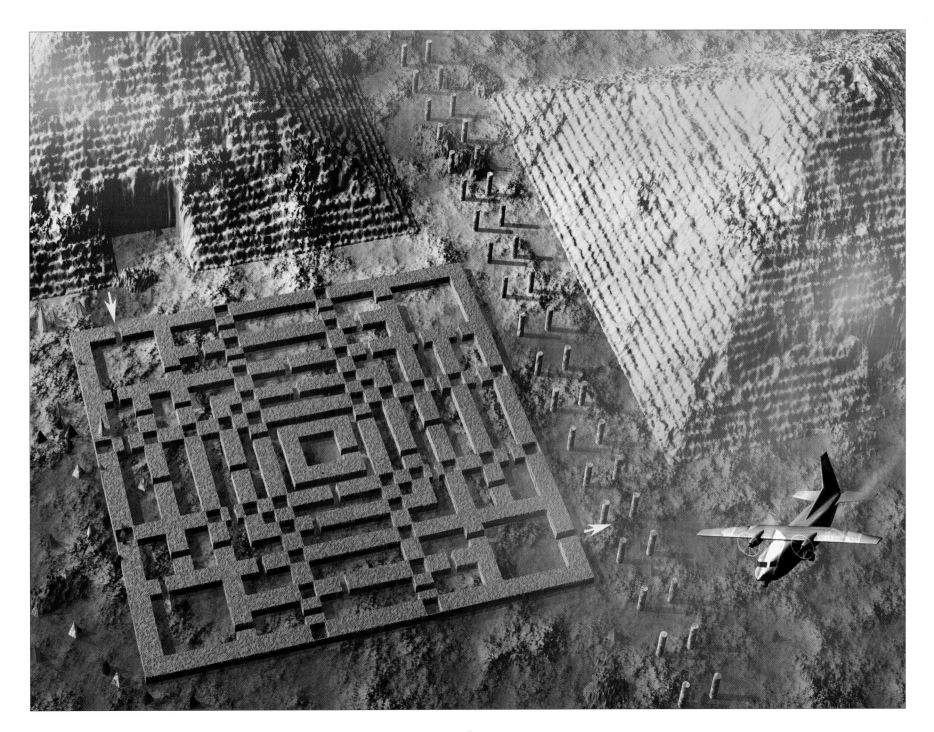

5

5

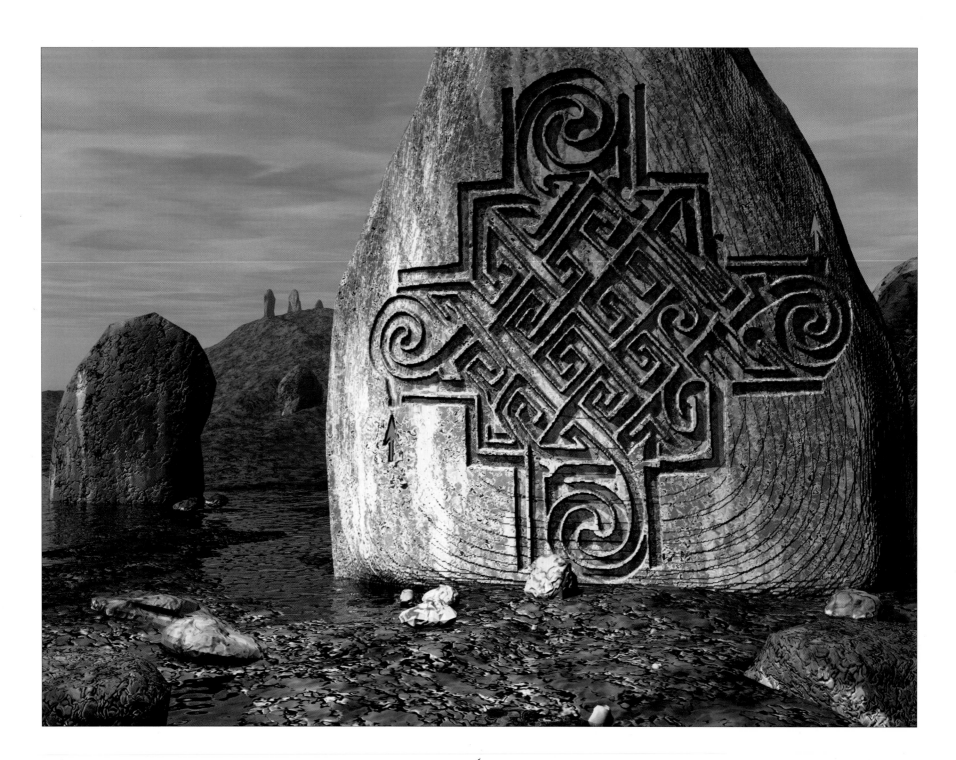

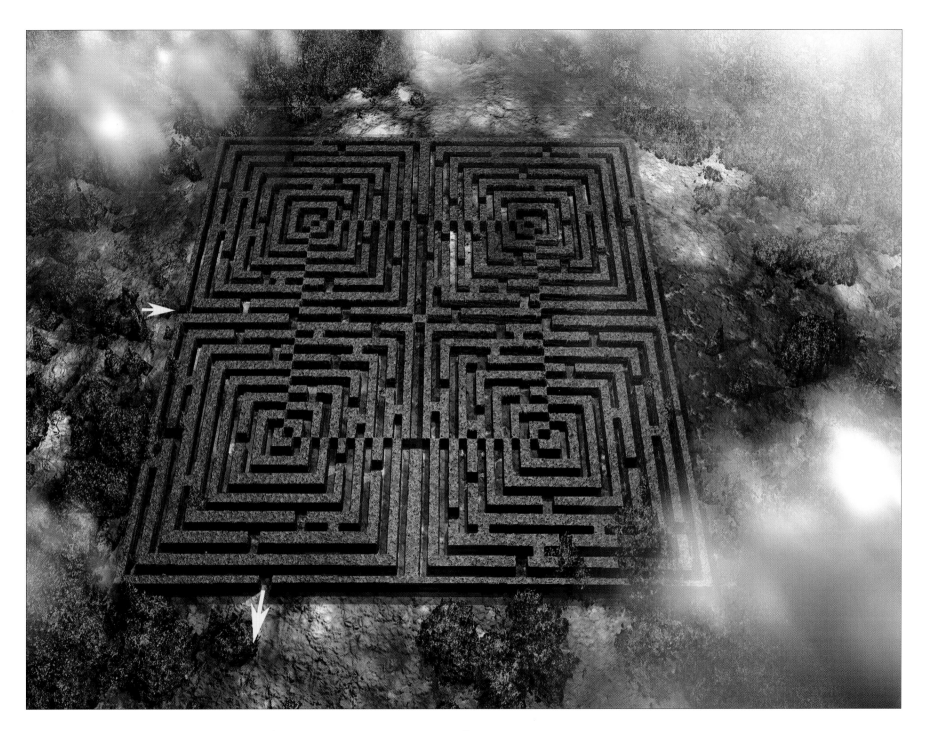

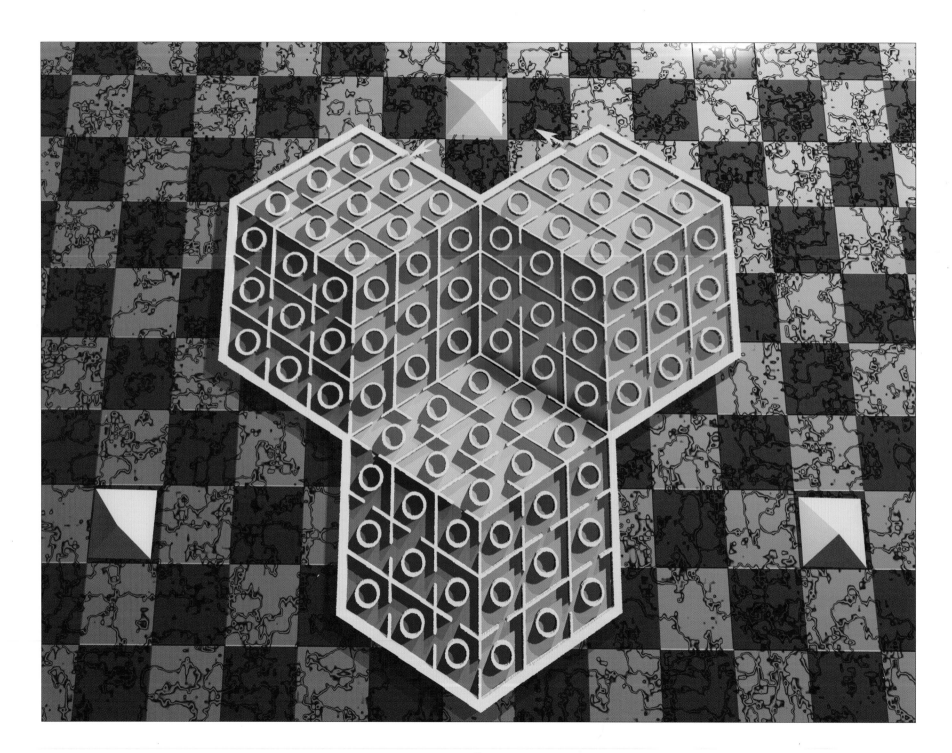

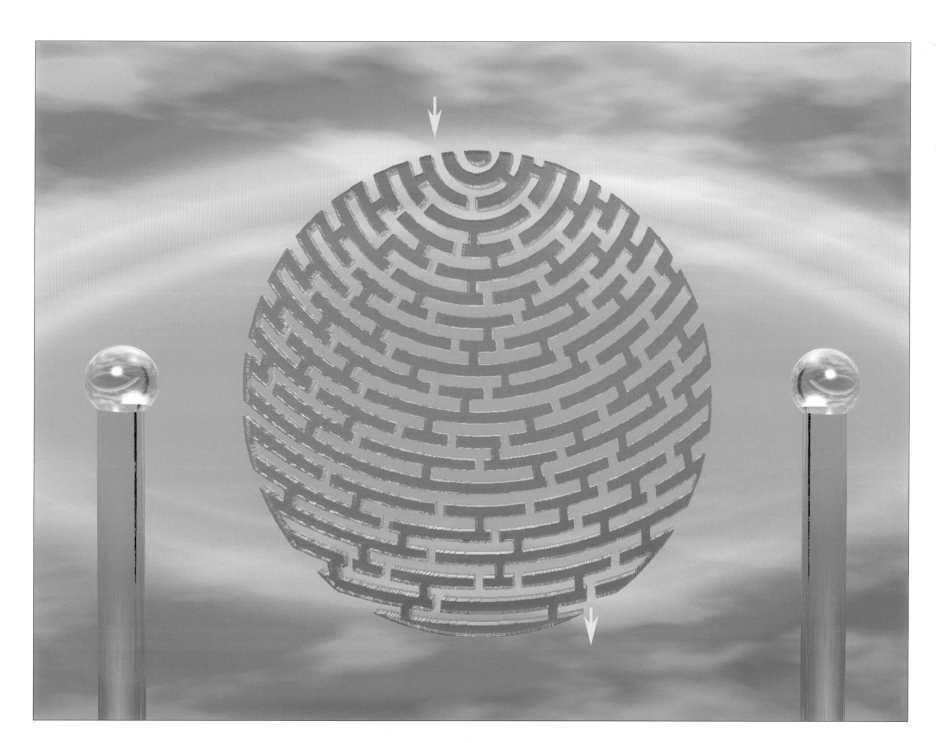

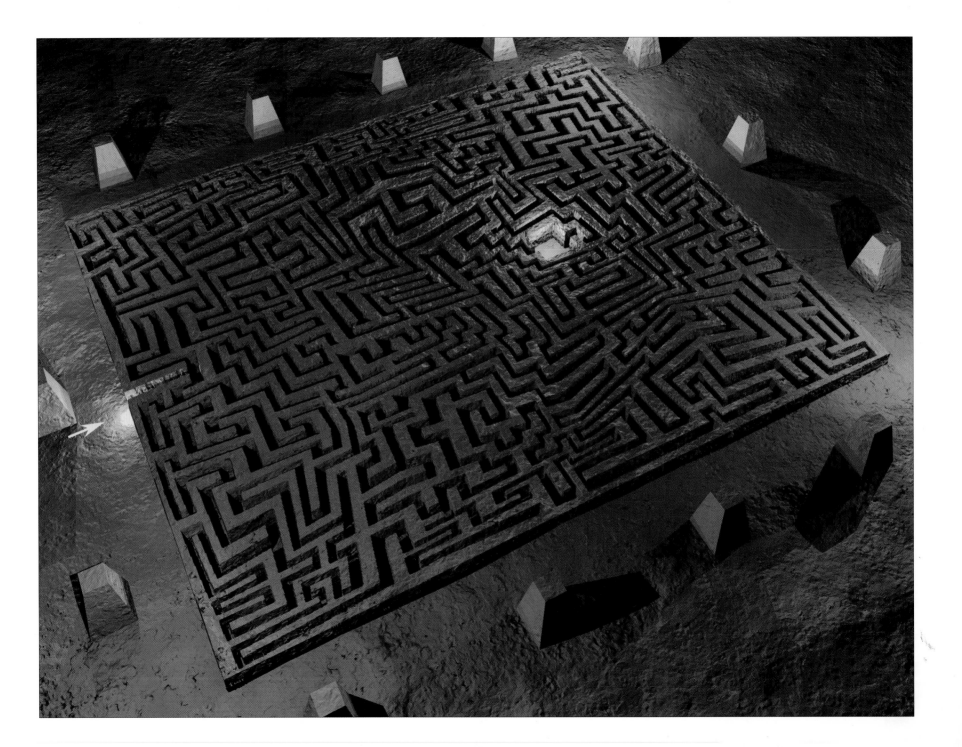

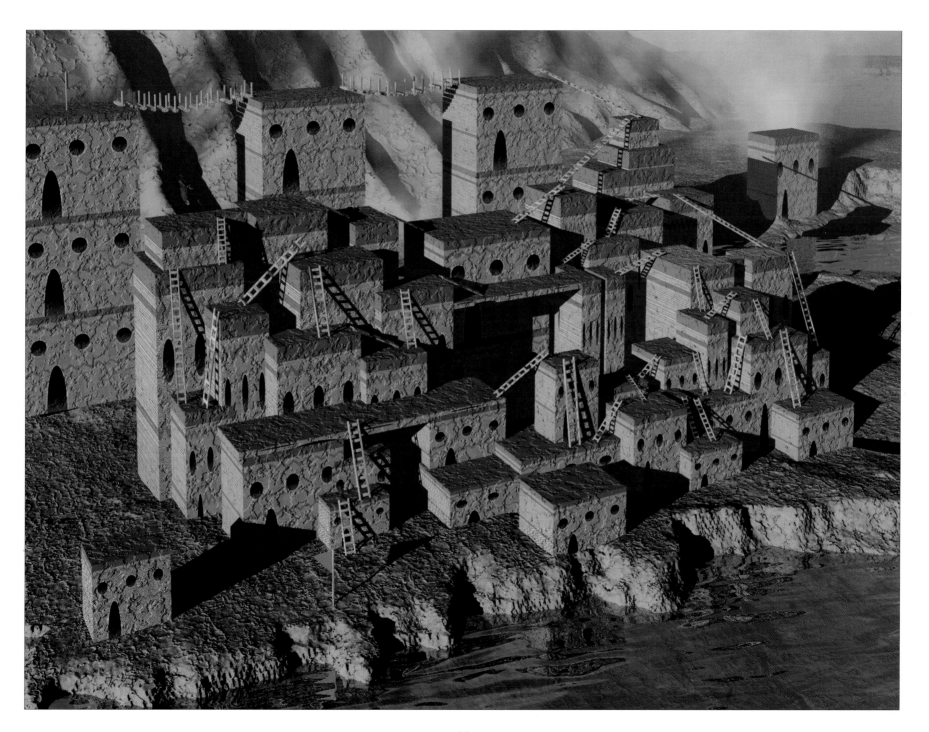

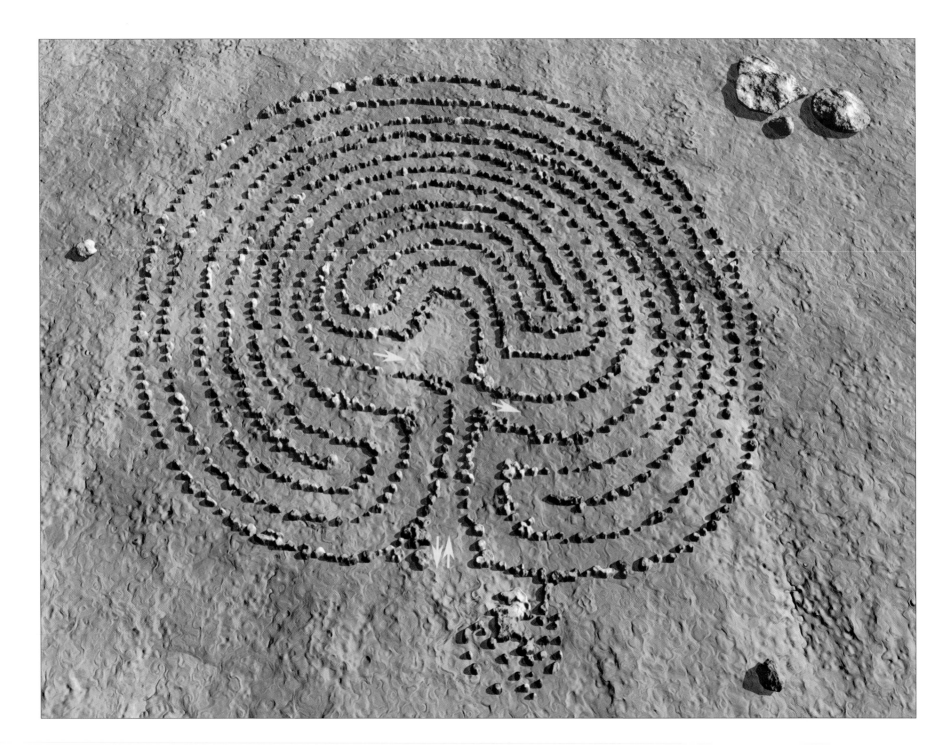

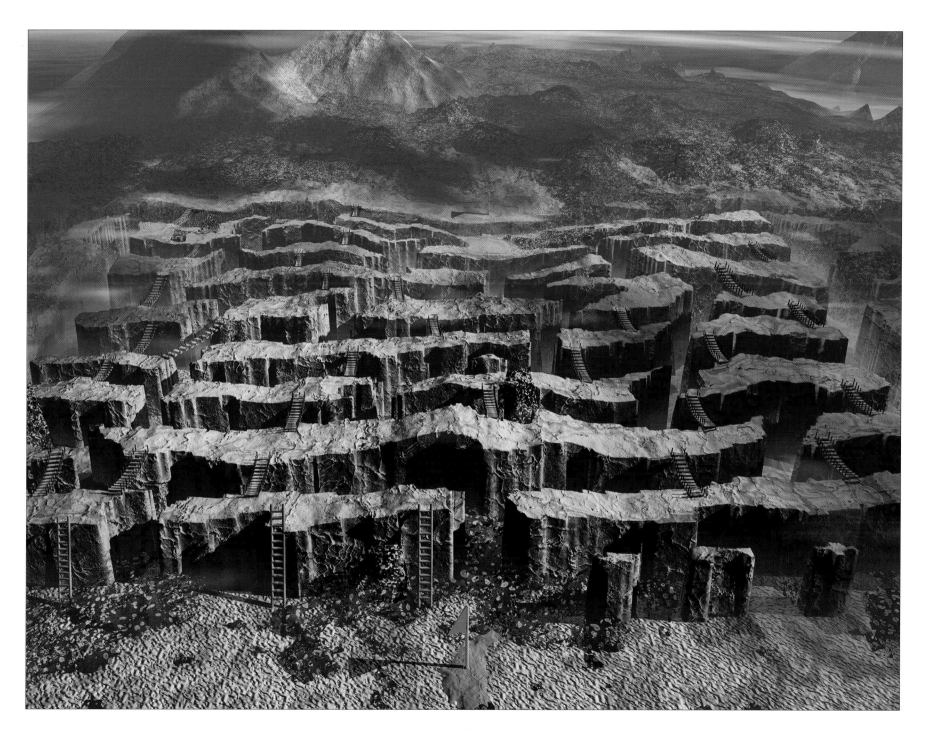

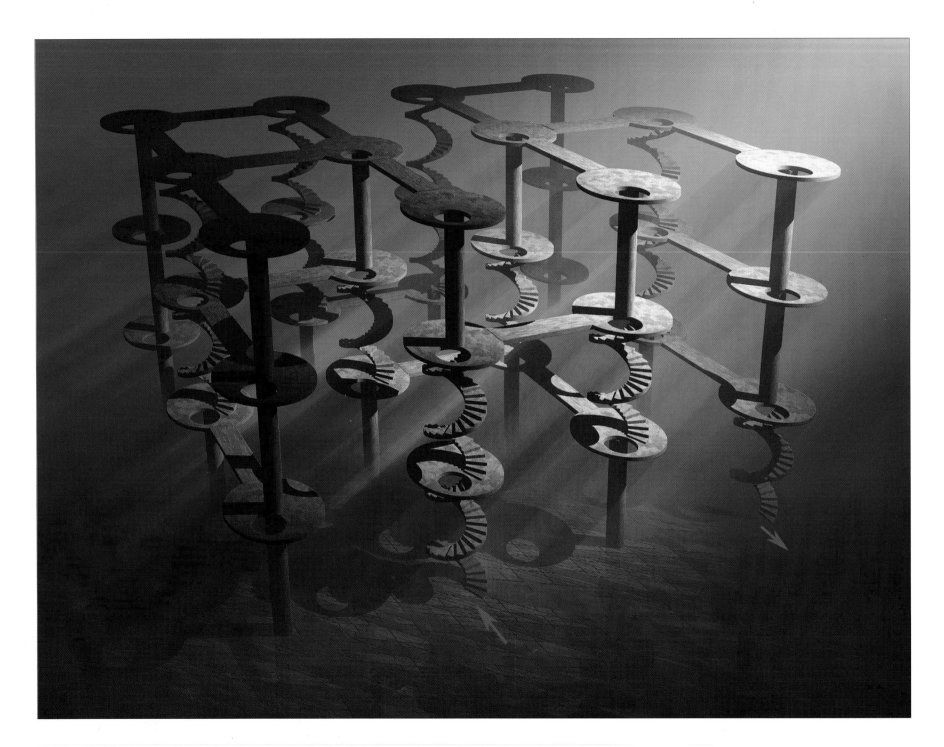

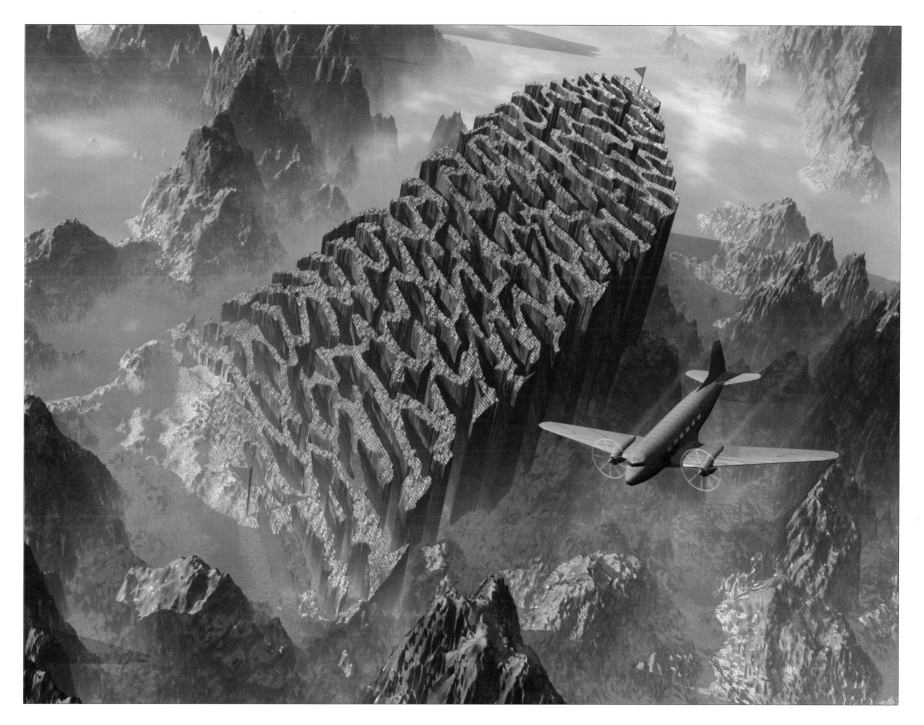

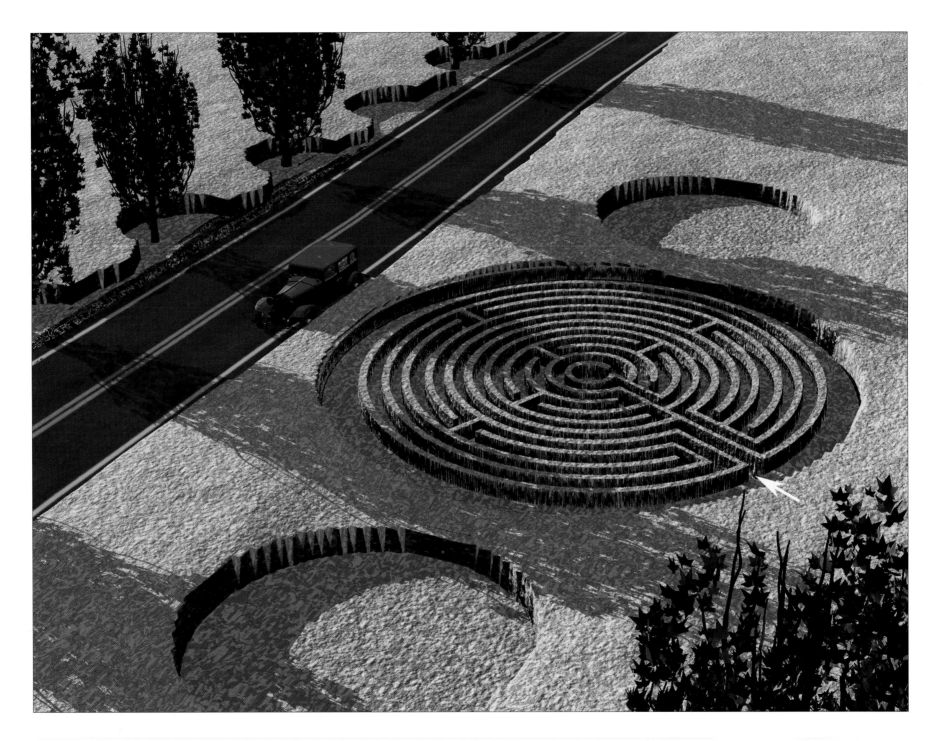

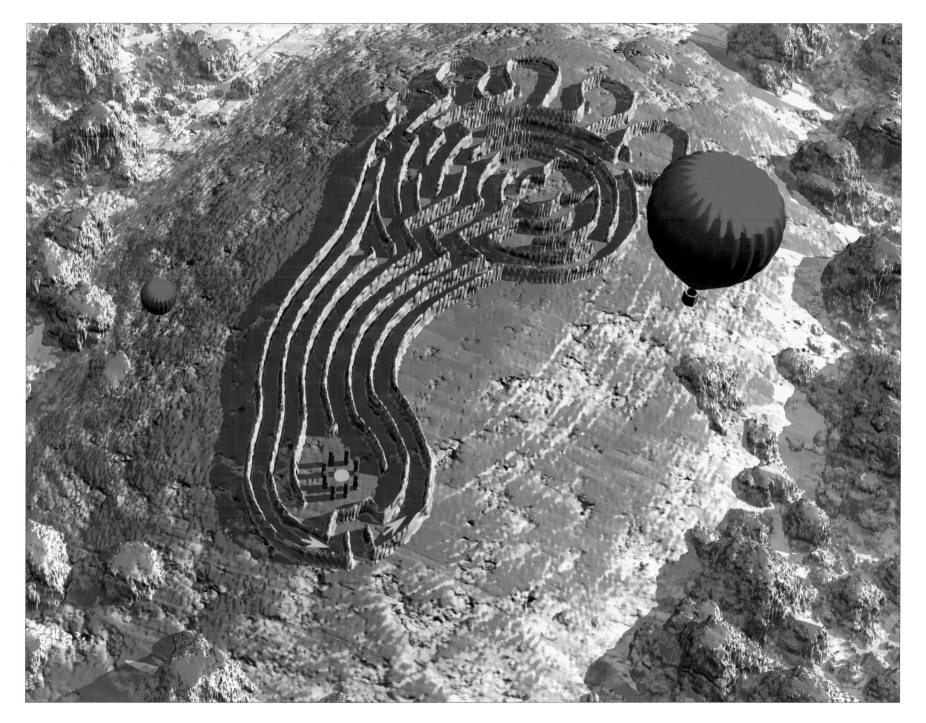

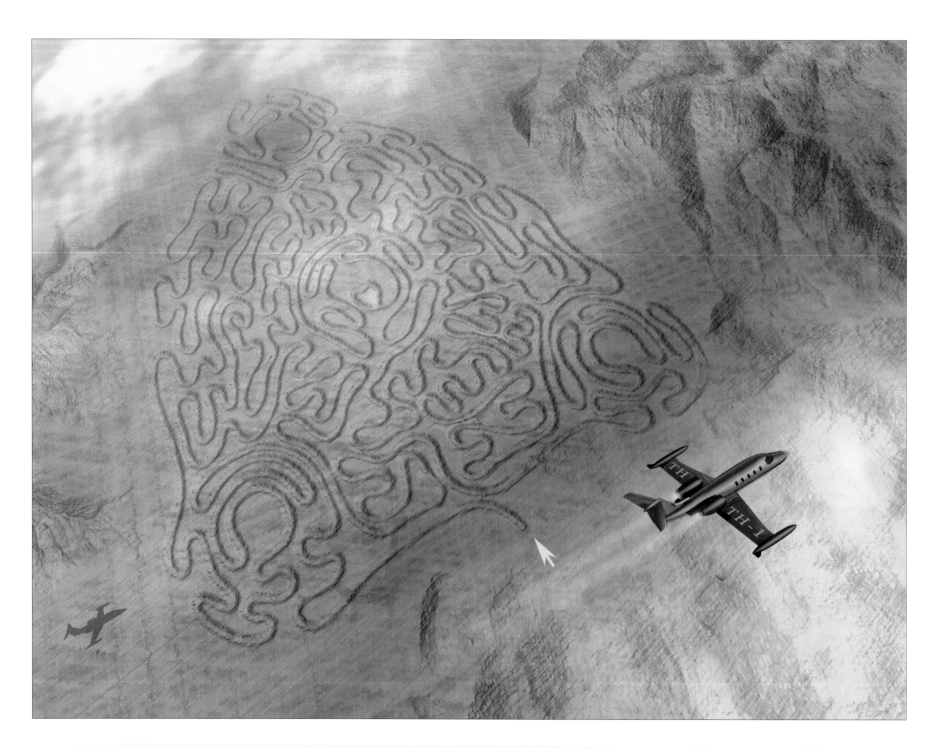

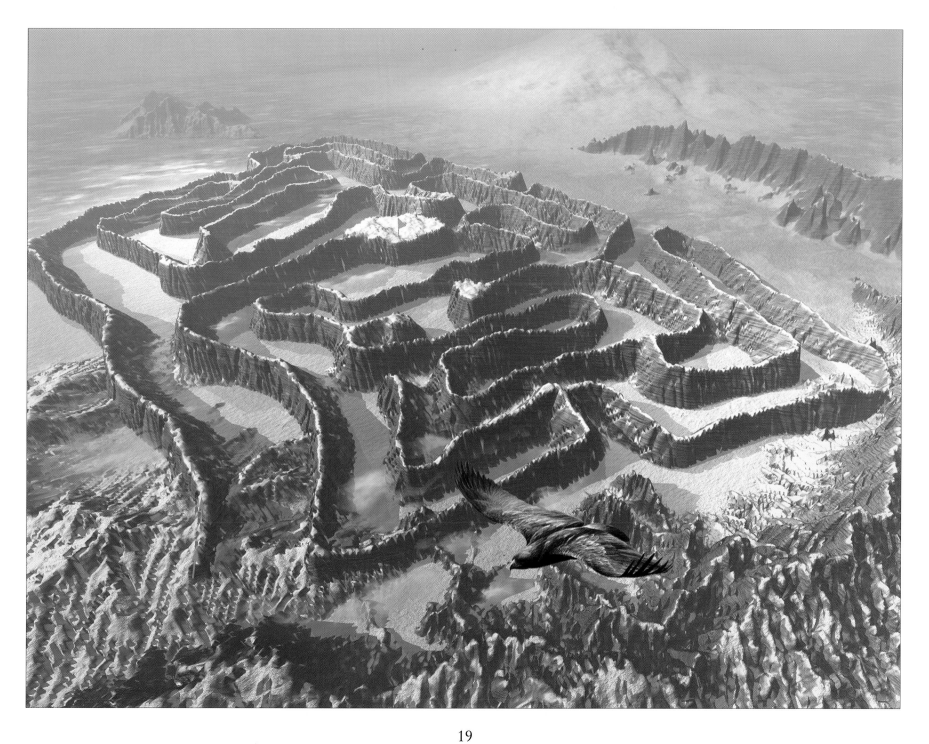

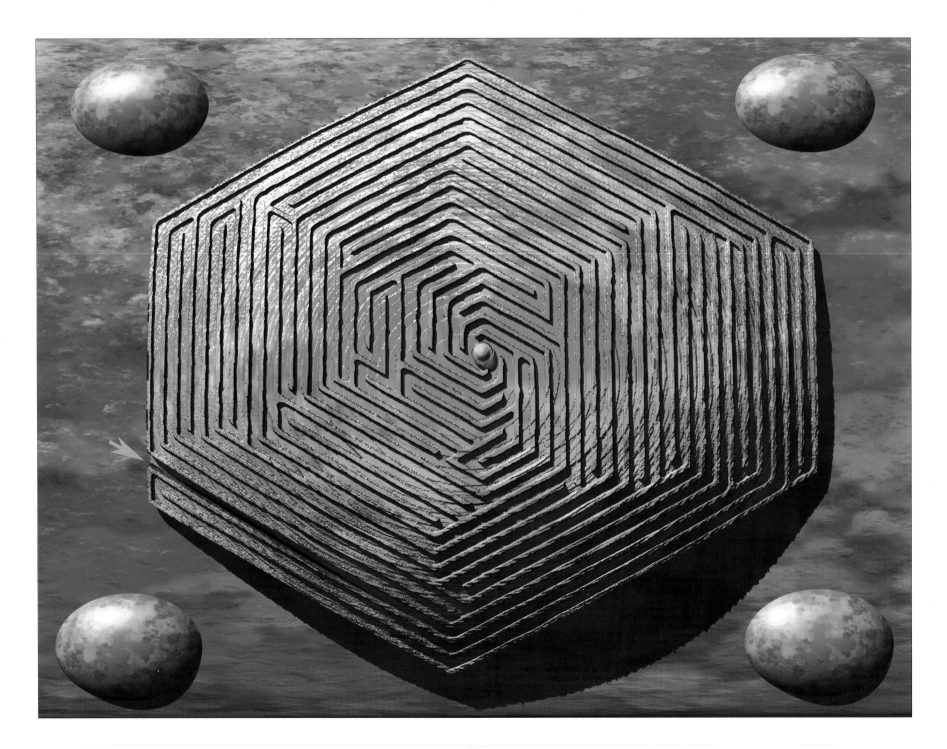

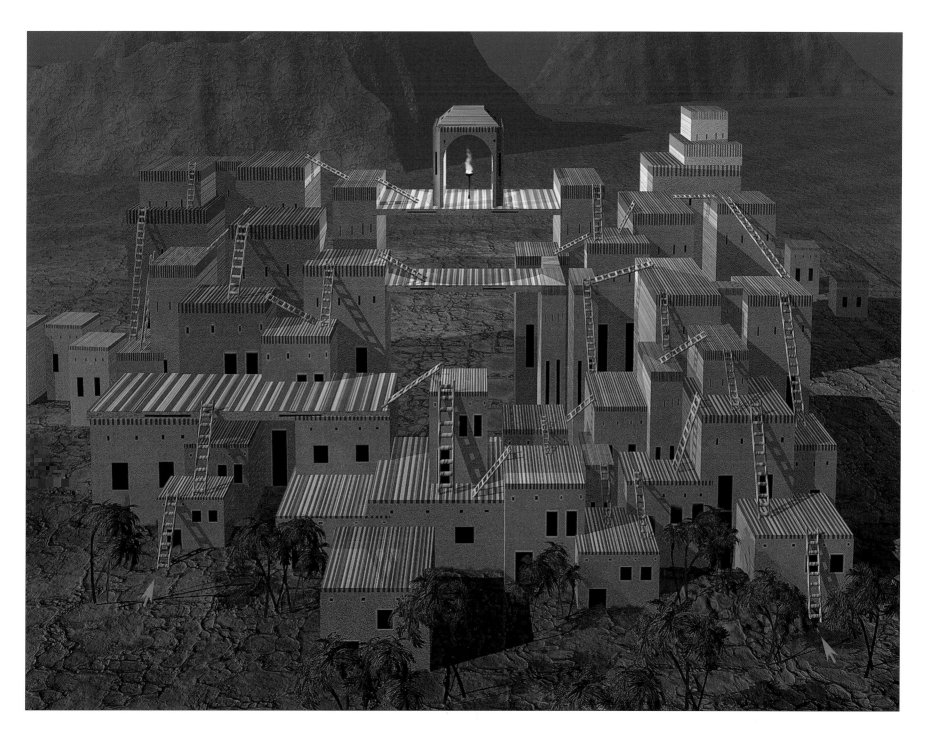

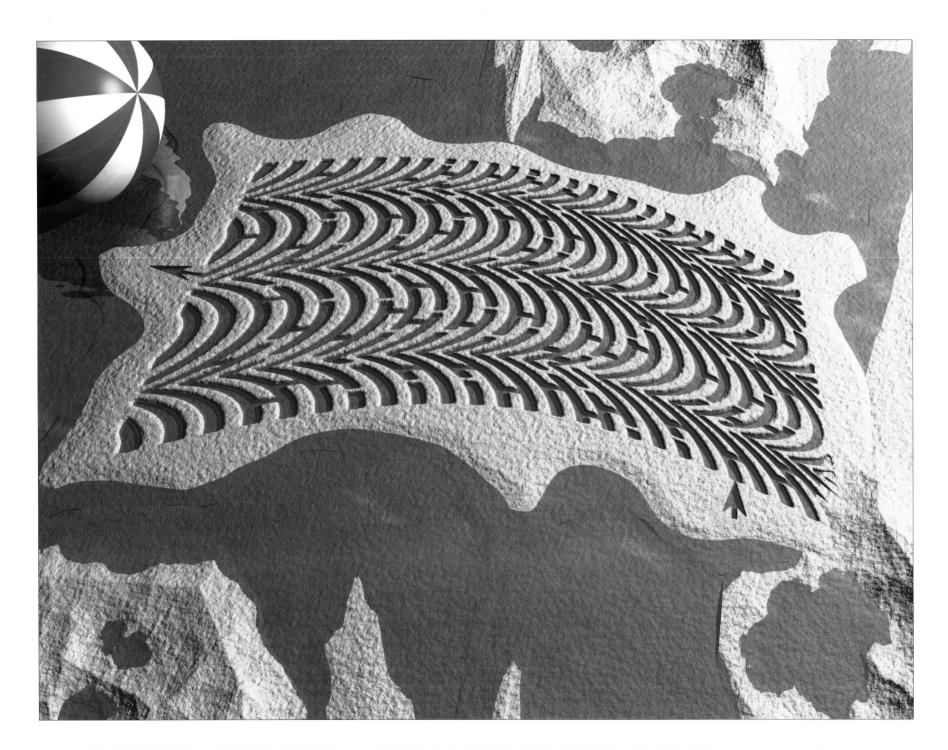

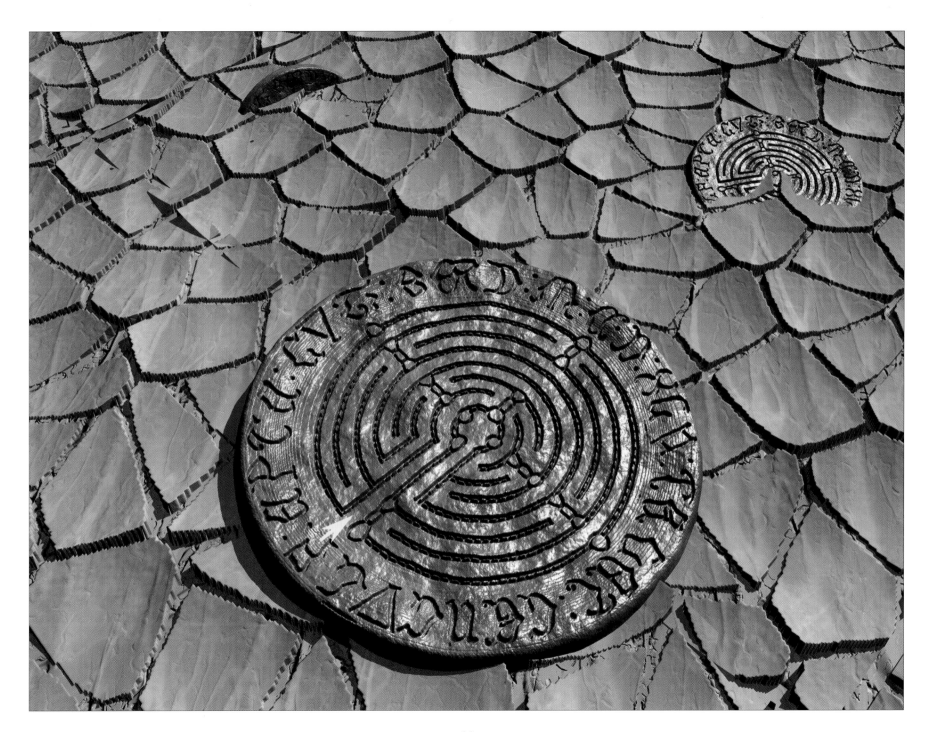

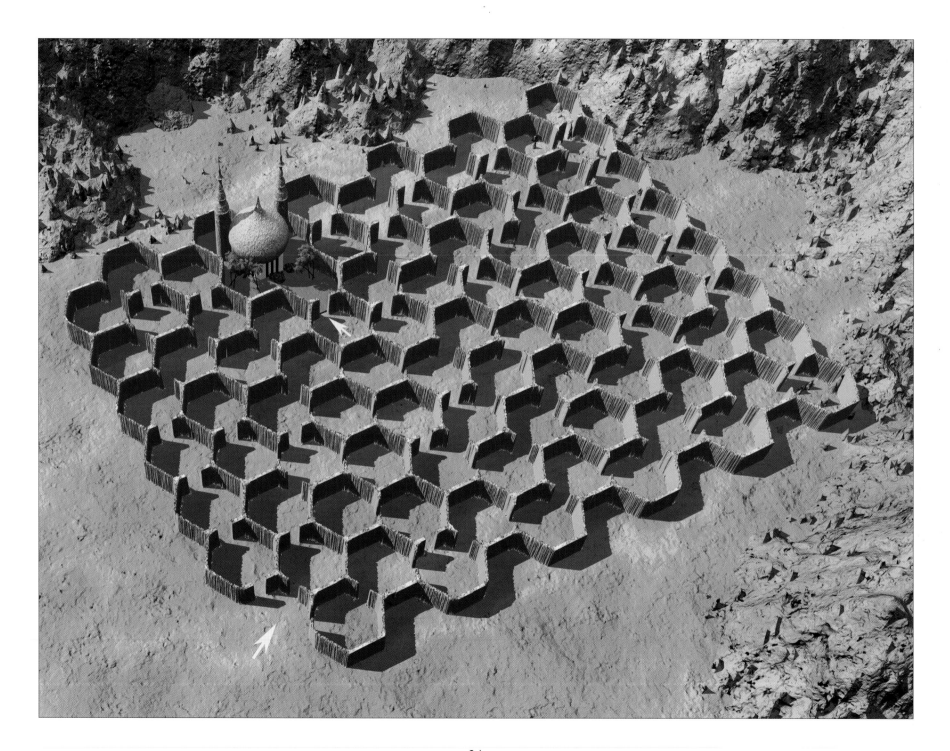

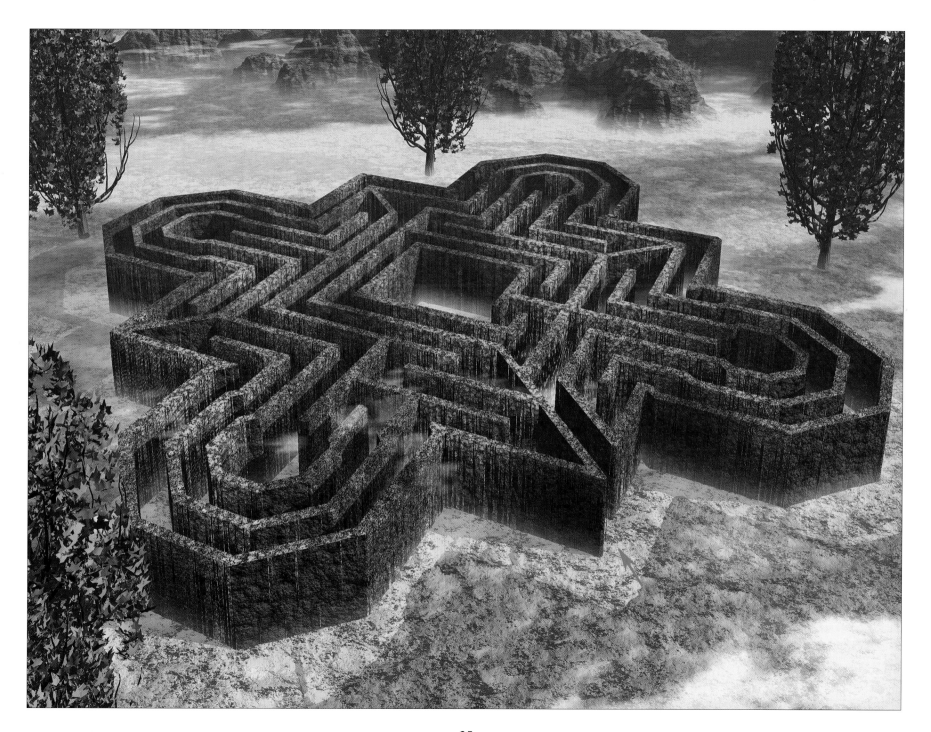

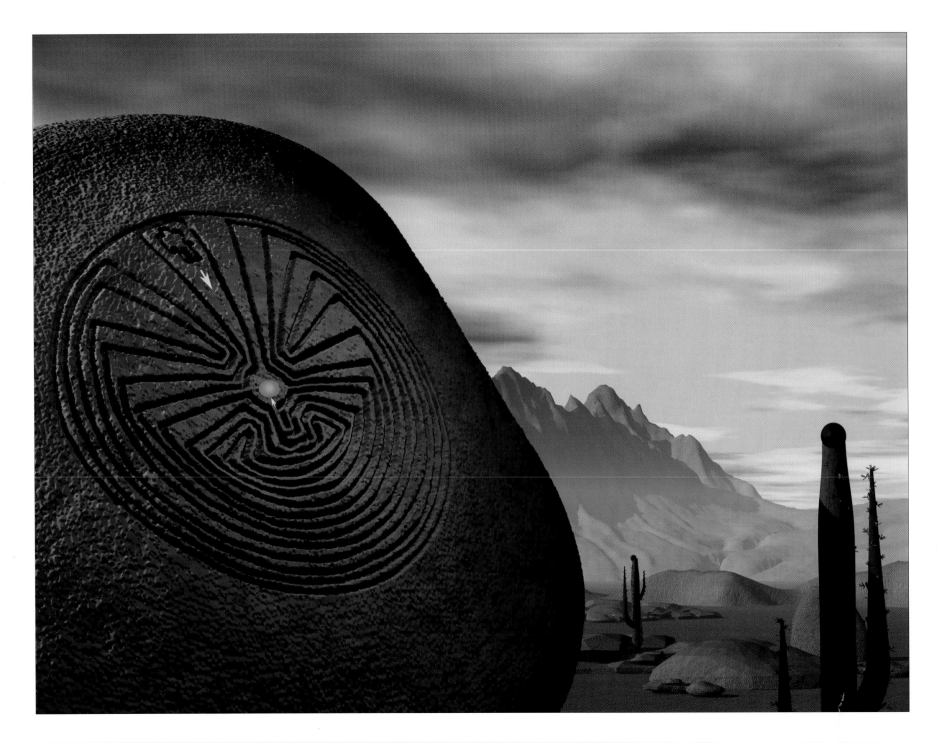

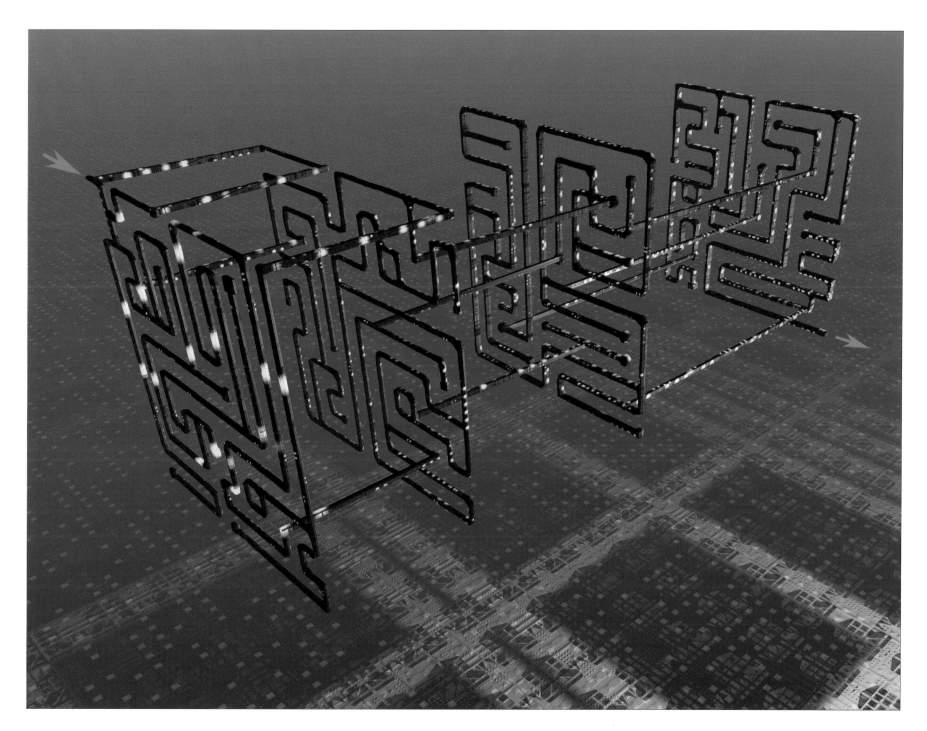

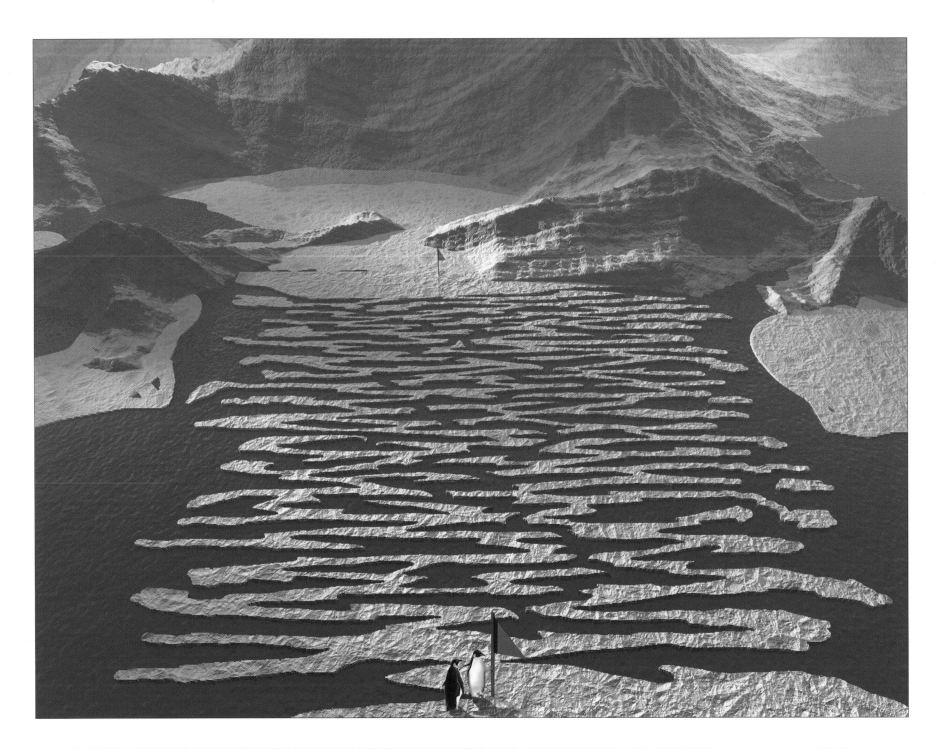

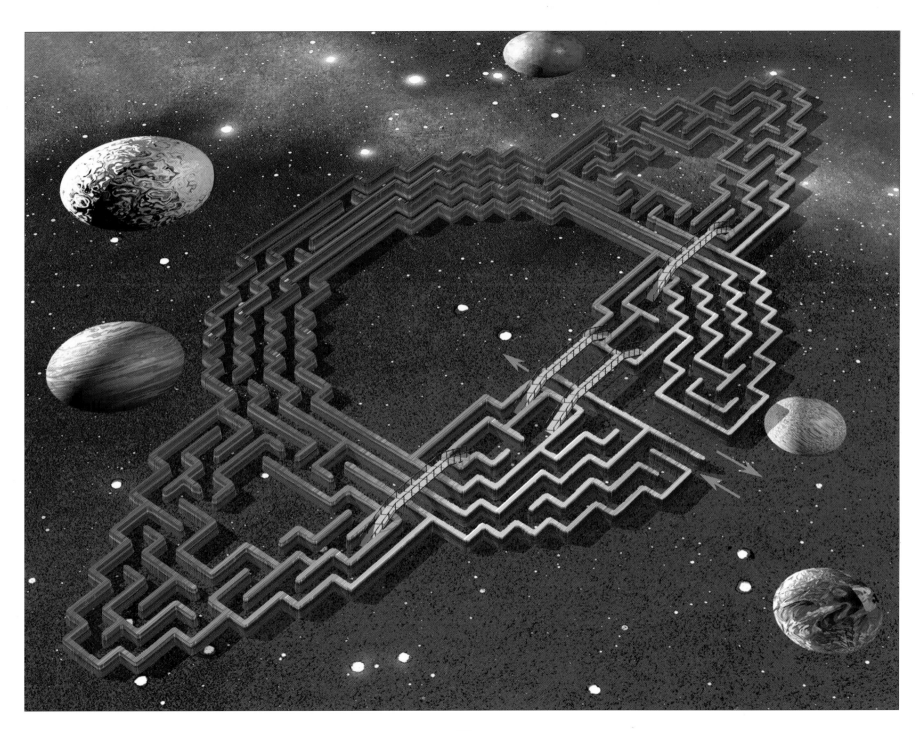

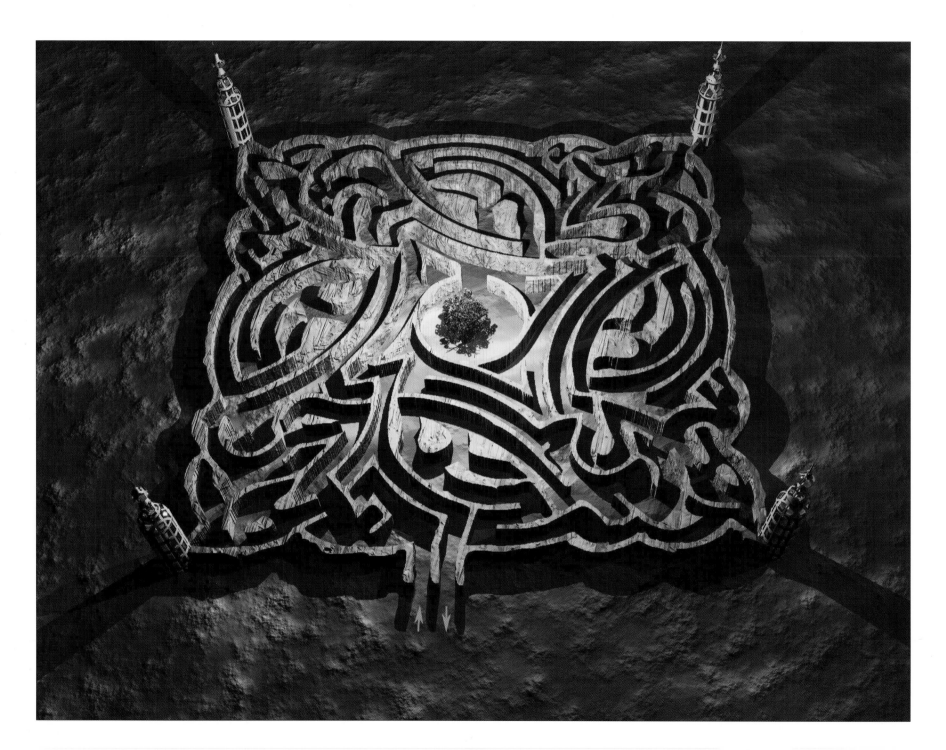

Solutions

The solutions for all labyrinths in this book are found on this and subsequent pages. Some labyrinths have several possible solutions; don't worry if you have found another one.

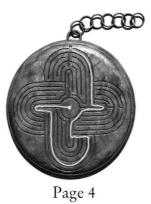
Page 3

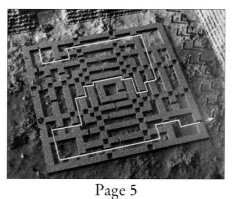
Page 4

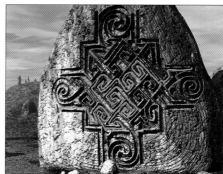
Page 5

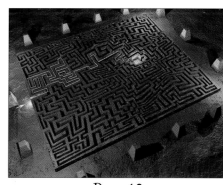
Page 6

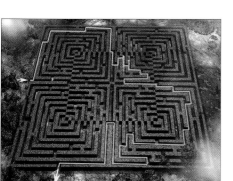
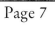
Page 7

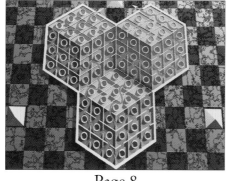
Page 8

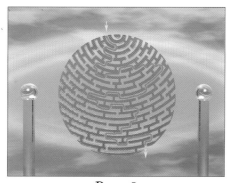
Page 9

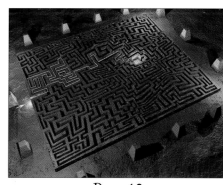
Page 10

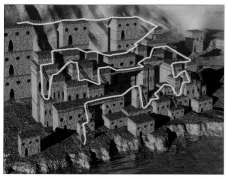
Page 11

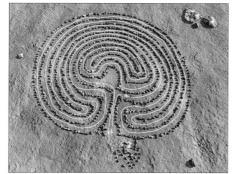
Page 12

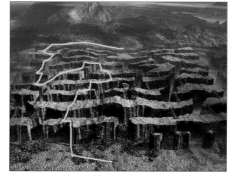
Page 13

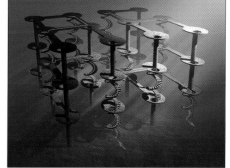
Page 14

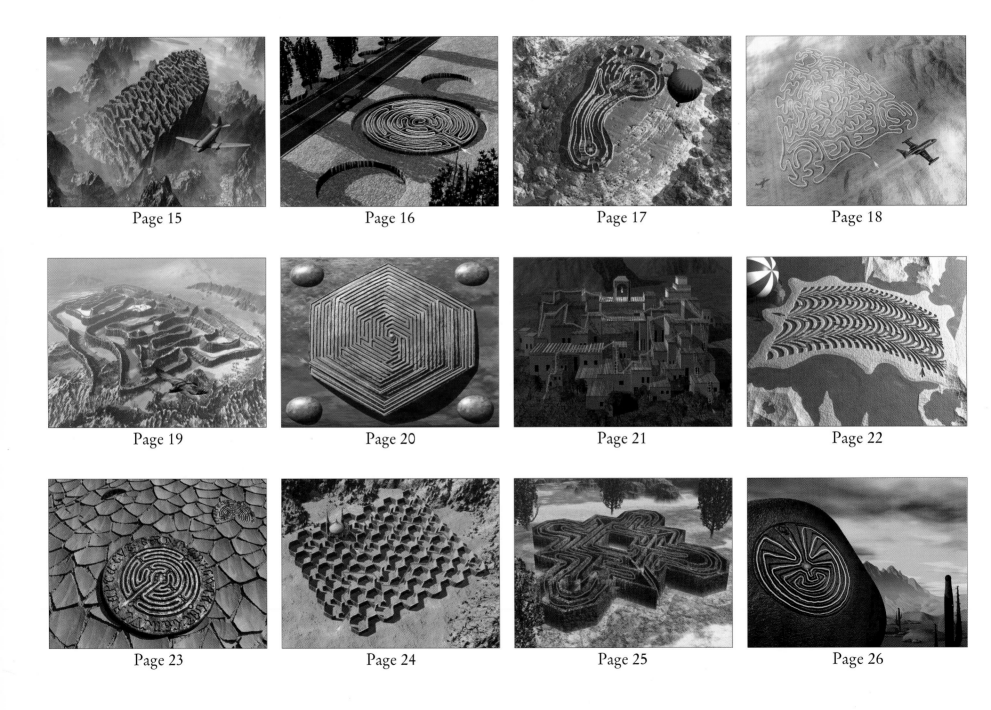

Page 15

Page 16

Page 17

Page 18

Page 19

Page 20

Page 21

Page 22

Page 23

Page 24

Page 25

Page 26

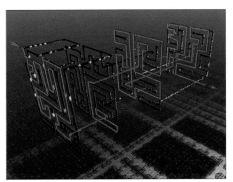
Page 27

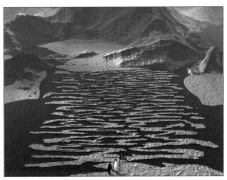
Page 28

Page 29

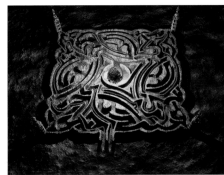
Page 30

Thomas Thiemeyer, born in 1963, studied art and geology in Cologne. While working as a graphic consultant at Ravensburger Book Publishing, he published his first book for adolescents. Since 1989, Thiemeyer has worked as a freelance graphic artist and illustrator. He also works as a cover illustrator, game developer, and computer graphic artist. He is currently writing his first novel. He lives with his wife and two sons in Stuttgart, Germany. For additional information, see http://www.thiemeyer.de/.

Bertrun Jeitner-Hartmann, born in 1943, was an editor, publisher, and translator of books for children and adolescents, as well as books on parent pedagogics with Ravensburger Book Publishing. She also studied child psychotherapy. She now works as a freelance editor, author, and translator for various publishers in child therapy and research on the intercultural daily routines of women. She lives with her husband, two children, and a dog in Nürnberg, Germany.

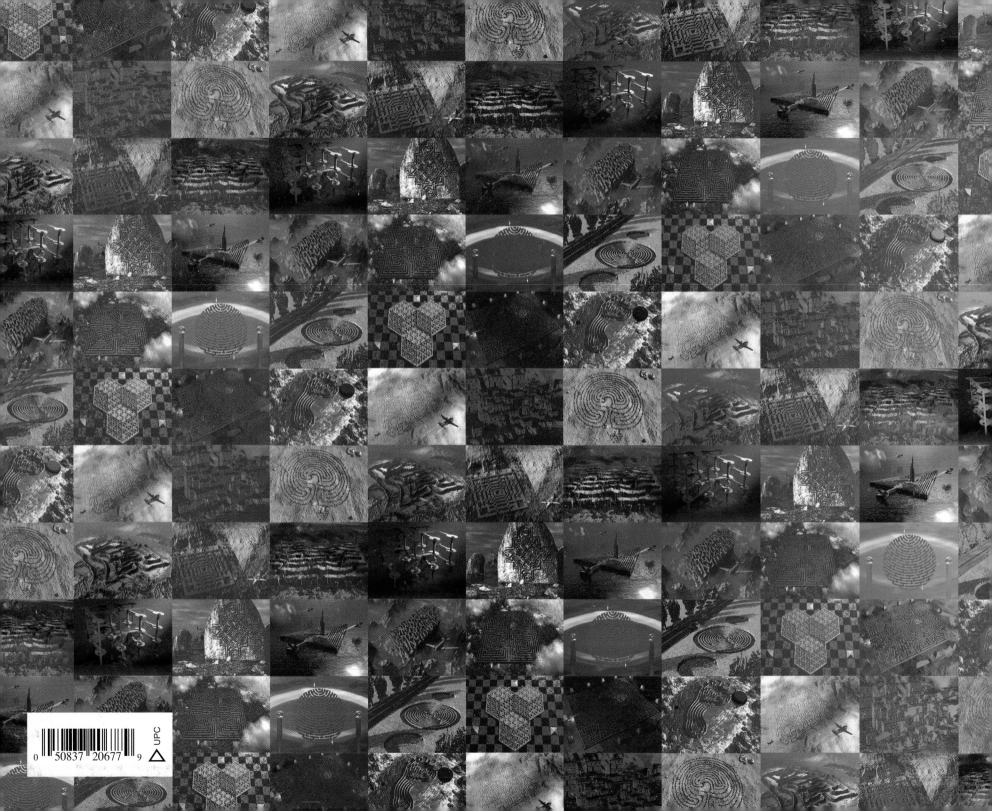